FREEMAN'S

The Vader Project Auction
07/10/10

Auction
Saturday, July 10th at 12pm

Sale 1375

Exhibition:
Monday, July 5 through Friday, July 9th
10am-6pm

Inquiries:
SIMEON LIPMAN EXT 3089
Pop Culture Specialist
Direct Tel: 267.414.1213
slipman@freemansauction.com

KATI GEGENHEIMER EXT 3009
Pop Culture Administrator
Direct Tel: 267.414.1212
kgegenheimer@freemansauction.com

Bidding:
BIDS DEPARTMENT
NATALIE DIFELICIANTONIO EXT 3008
Direct Tel: 267.414.1208
Fax: 215.599.2240
ndifeliciantonio@freemansauction.com

Catalogue $40

Freeman's
1808 Chestnut Street
Philadelphia, PA 19103
Telephone: 215.563.9275
Fax: 215.563.8236
www.freemansauction.com

126 Garrett Street
Charlottesville, VA 22902
Telephone: 434.296.4096
Fax: 434.296.4011
www.freemanssouth.com

Color images of every lot
are available on
www.freemansauction.com

Color separations and prep:
Brilliant, Exton, PA
Printing and Binding:
Artron Brilliant, China

Important Information for Buyers

Registration
All potential buyers must register for the sale prior to placing a bid. Registration information may be submitted in person at our reception desk, by fax or through our website at www.freemansauction.com. We will require proof of identification and residence and may require a credit card and/or a bank reference. By registering for the sale, the buyer acknowledges that he or she has read, understood and accepted Freeman's Terms and Conditions of Sale.

Buyer's Premium
A Buyer's Premium will be added to the successful bid price and is payable by the buyer as part of the total purchase price. The Buyer's Premium shall be: 25% on the first $20,000 of the hammer price of each lot, 20% on the portion from $20,001 through $500,000, and 12% on the portion of the hammer price exceeding $500,000.

Sales Tax
All items in the catalogue are subject to the 8% Pennsylvania and Philadelphia sales tax. Dealers purchasing for resale must register their tax numbers on current PA forms. Forms should be submitted to our Client Services office on the second floor.

Catalogue Descriptions
All item descriptions, dimensions and estimates are provided for guidance only. It is the buyer's responsibility to inspect all lots prior to bidding to ensure that the condition is to their satisfaction. If potential buyers are unable to inspect lots in person, our specialists will be happy to prepare detailed Condition Reports on individual lots as quickly as possible. These are for guidance only, and all lots will be sold "as is" as per our Terms and Conditions of Sale.

Bidding
At the sale Registered bidders will be assigned a bidder number and given a paddle for use at the sale. Once the first bid has been placed, the auctioneer asks for higher bids in increments determined by the auctioneer. To place your bid, simply raise your paddle until the auctioneer acknowledges you. The auctioneer will not mistake a random gesture for a bid.
By phone A limited number of telephone lines are available for bidding by phone through a Freeman's representative. Phone lines must be reserved in advance. Requests must be submitted no later than 24 hours prior to the scheduled start of the sale.
In writing Bid forms are available in the sale room and at the back of the catalogue. These should be submitted in person, by mail or by fax no later than one hour prior to the scheduled start of the sale. The auctioneer will bid on your behalf up to the limit indicated, but is not responsible for errors or failure to execute bids.
On the internet A fully-illustrated catalogue is available on-line at www.freemansauction.com. Registered bidders may bid live or leave absentee bids through the web site and will receive email confirmation of their bid. Freeman's is not responsible for errors or failure to execute bids.

Payment
Lots purchased will not be released until we have received full payment. Payment may be made in cash, by check, money order, or debit card. Payments by check must clear the bank before goods will be released.

Removal of Purchases
Deliveries will not be made during the time of the sale unless otherwise indicated by the auctioneer. All items must be paid for and removed by July 23rd at 3pm. Purchases not so removed may be turned over to a licensed warehouse at the expense and risk of the purchaser.

Shipping and Packing
Responsibility for packing, shipping and insurance shall be exclusively that of the purchaser. Upon request, Freeman's will provide the purchaser with names of professional packers and shippers known to us.

The Vader Project Auction

Saturday, July 10th at 12pm

It couldn't have happened any other way.

DKE Toys was a young company, but growing every day. We were looking for something to put us on the map. Why not a platform art show where each artist designs and customizes the same object? By 2005 we had already seen every platform show imaginable from designer toys to Maryland crabs. But Dov said, "What do you think about Darth Vader?" It would really make an amazing platform. And, we knew a guy! Our pal Ronnie Goldfinger was a fellow toy distributor and one of the founders of Master Replicas, the licensee for the Vader helmet. We had our first meeting in 2006 at New York *Toy Fair* and Ronnie made the introduction. They loved it!

The main issue though was that a life-size 1:1 prop replica Darth Vader helmet retails for $900 and we wanted 100 of them! Fortunately for us they had a bunch sitting in a warehouse in China that were not saleable due to a production problem. We flew to Walnut Creek, California for the final meeting. We got all the okays we needed and before we knew it, the helmets were in our living room.

They arrived to us primed white and ready to paint, a bold blank canvas. We had no idea what to expect as the real work had yet to begin. We were looking for a new take on the classic design, and we made our "Wish List" of artists we wanted to be in the show. Almost everyone said yes! These creators, artists, and designers are the best in their fields from the worlds of Lowbrow, Pop Surrealism, Underground, Street, Graffiti, Tattoo, Rock Poster, Apparel and Designer Vinyl Toys.

Within a month of the first batch going out, boxes started to arrive. Ugly Doll creators Dave Horvath & Sun-Min Kim's "All Star, No War" was the first. We unpacked the box and looked at each other. We couldn't believe what we had in front of us. Helmets from Dalek and Ron English showed up and we knew we had something. We displayed them on our kitchen counter to see reactions from people visiting our box-filled home business. People were all smiles.

Around the beginning of 2007 we got the news that *Star Wars Celebration IV* was coming to our hometown of Los Angeles and they wanted us to display *The Vader Project* there. Due to business decisions beyond our control, the licensee was suddenly out of the picture and we now had no sponsor. The ownership and creative control of the show fell into our laps and so did the bills. Suddenly we went from being just curators to show producers and promoters. We had an army of 66 different Darth Vader helmets standing in rows and filling up a 5,000 square foot room at the Los Angeles Convention Center. We didn't know what people would think;

LA Weekly/Rena Kosnett

it was hard for us to imagine that anyone would even care. We only knew that we thought it was pretty cool. Over the course of five days 20,000 people came through the doors, stayed longer than we imagined and took pictures of each piece. Overnight, *The Vader Project* went from a few hits about Danish fathers to over 40,000 hits on Google. The fans loved it! People waited over an hour to get in, and any doubts we had about the show evaporated.

Darth Vader is a universal cultural icon. As a platform, it actually wasn't as blank a canvas as we thought. Painting an American flag on Vader's face or making him into the Statue of Liberty made an immediate statement. The artists were able to play against type or with Vader's themes. Even more fascinating were the fans' interpretations, which spanned the gamut from heroic to tragic.

After Los Angeles the show traveled to London for *Star Wars Celebration Europe* (July 2007) and then to *Star Wars Celebration Japan* (July 2008) where we were presented with the opportunity to add over a dozen Japanese artists. This group included some of the best-known and innovative designers and artists in the Japanese soft vinyl toy movement.

Then, in February 2009, our wildest dreams came true when the show opened at the prestigious Andy Warhol Museum in Pittsburgh, Pennsylvania with all 100 helmets...and record crowds. Like proud parents, we were overwhelmed as we watched our show graduate from an underground vision of a pop icon to an important contemporary art collection.

From a simple idea in 2005 to a record-setting exhibition in 2009, it has been quite a journey. Now it's time for our child to venture forth into the world. We are pleased to have partnered with Freeman's to make these fine pieces of art available to the public for the first time.

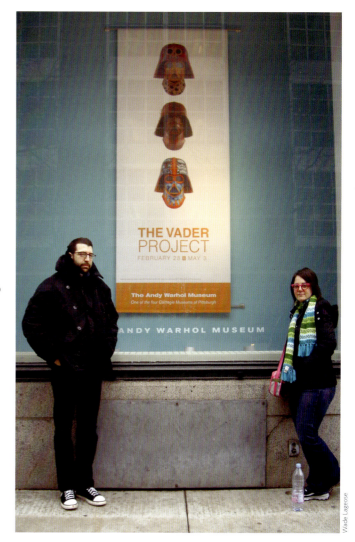

Wade Lageose

Dov Kelemer & Sarah Jo Marks
Curators
The Vader Project
MAY 2010

Dov and Sarah Jo would like to thank the
following people without whose contributions
this show could not have been possible:

Ronnie Goldfinger
Simeon Lipman
Our families
Noel Aladadyan
Christine Anderson
Rick Armstrong
Ivan Arnold
Attaboy
Julie B.
Doug Baily
John Boiler
Reagan Bond
Keith Bornholtz
Christopher Browne
Bonnie Burton
Blair Butler
Jim Byrnes
Justin Carbon
Nate Carle
Sophia Cesaro
Glenn Cole
Casey Collins
Michael Cookson
Crystal Pharoah
Michael DeCastro
Jay Demircift
Nathan DiMercurio
Gaston Dominguez-Letelier
Hanna Dougher
Gerry Duggan
Amy Duran
Bonnie Eck
Nate Eckman
Barry Eldridge
Margaux Elliott
Tarssa English
Darren Epstein
Stephanie Escobar
Sean Fallon
Adam Fisk

Brian Flynn
Chick Fontaine
Mary Franklin
Beau Freeman
Barry Friedland
Colonel Galaxy
Sophia Gan
Ayleen Gaspar
George Gaspar
Roger Gastman
Kati Gegenheimer
Shane Geil
Marty Geramita
Jon M. Gibson
Jimmy Giglio
Jenny Gillette
Chris Gore
Rory Grennan
Angelique Groh
Susan Hancock
Haze XXL
Andy Heng
Secretbase Hiddy
Katie Hill
Jeremy Hoffman
Joanee Honour
William Hough
Tom Hunter
Nick Hurwitch
David Iskra
Matt Jarvis
Long Gone John
Nicholas Johnson
Josh Kade
Matt Kennedy
Angela Kimbrough
Brian Kinoshita
Christine Knapp
Jessica Koslow
Rena Kosnett

Jay Koval
Jeremy Kove
Heather Kowalski
Jesse Kowalski
Frank Kozik
Sharon Kozik
fig-lab/Don "datadub" Kratzer
l.a.Eyeworks
Wade Lageose
Patrick Lam
Tom Leon
Kendra Liebowitz
Ryan Liebowitz
Sharon Liebowitz
Justin Lubin
Leo E. Lundberg Jr.
Megan Mair
Cindi Manning
Chika Masuda
Kathy A. McDonald
Lisa McLain
Sean McLain
Pooneh Mohajer
Buff Monster
Gosei Mori
Ernae Mothershed
Mitsuaki Munegumi
Jack Muramatsu
Eric Nakamura
Jan Neiman
Alasdair Nichol
olive47
Brian Ono
Eriberto Oriol
Diane Owen
Annie Owens
Jhizet Panosian
Ronald E. Perez
Glenn Pogue
Ionut Popescu

Derek Puleston
Matt Revelli
Jessica Reznick
Ed Riggins
Jamie Rivadeneira
Paul Roberts
Frank Rogala
Luke Rook
Dan Rosier
Deborah Ross
Steve Sansweet
Nina Savill
Helen Hood Scheer
Theodore Schraff
Brandon Schultz
David Scroggy
Bob Self
Rani Self
Scott Seraydarian
Billy Shire
Brian Slivka
Clif Smith
Thomas Sokolowski
Paul Southern
John Stinsman
John "Spanky" Stokes
Sucklord
Mark Suroff
Colin Turner
Bob Tursack
Michelle Valigura
Kathy Van Beuningen
Janice Van Wagner
Amanda Visell
Beverly Weitzman
Amanda White
Dan Willett
Amy Jo Wimmer
Brandon Scott Wright
501st Legion

VADER HELMET STUDIO PHOTOGRAPHY: BUFF MONSTER

The Vader Project Exhibitions

MAY 24-28, 2007
Star Wars Celebration IV
Los Angeles Convention Center
Los Angeles, California, U.S.A.

JULY 13-15, 2007
Star Wars Celebration Europe
ExCel Exhibition Center
London, England

JULY 25-29, 2007
San Diego Comic-Con
San Diego Convention Center
San Diego, California, U.S.A.

JULY 19-21 2008
Star Wars Celebration Japan
Makuhari-Messe Convention
Center
Tokyo, Japan

FEBRUARY 4, 2009
**Lucasfilm Annual Employee
Meeting**
Marin County Civic Center
San Rafael, California, U.S.A.

FEB 28-MAY 3, 2009
Andy Warhol Museum
Pittsburgh, Pennsylvania, U.S.A.

JUNE 11-20, 2010
**Freeman's Los Angeles Auction
Preview**
Los Angeles, California, U.S.A.

JULY 5-9, 2010
**The Vader Project Auction
Exhibition**
Freeman's Auction House
Philadelphia, Pennsylvania,
U.S.A

1
JOSH AGLE (SHAG)
(B. 1962)
Darth Tipua
Acrylic paint

$4,000-6,000

TROY ALDERS

2
TROY ALDERS
(B. 1965)
Peace Vader
Enamel spray paint

$3,000-5,000

3
KII ARENS
(B. 1967)
DARTH Vader
Acrylic and oil paint

$3,000-5,000

ATTABOY

4
ATTABOY
(B. 1974)
inVader of the Brine
Acrylic paint

$3,000-5,000

5
ANTHONY AUSGANG
(B. 1959)
Darth Vader is Gay
Spray paint and adhesive vinyl

$3,000-5,000

ANTHONY AUSGANG

AXIS

6
AXIS
(B. 1973)
Support Your Local Sith
Automotive and One Shot paint

$4,000-6,000

7
AYE JAY
(B. 1976)
Untitled
Paint on spray paint and acrylic paint

$3,000-5,000

AYE JAY

GARY BASEMAN

8
GARY BASEMAN
(B. 1960)
Untitled
Acrylic

$6,000-8,000

9
ANDREW BELL
(B. 1978)
Darthodontics
Resin, metal, and acrylic

$3,000-5,000

10
TIM BISKUP
(B. 1967)
Honor Thy Father
Cel vinyl acrylic

$4,000-6,000

11
MARK BODNAR
(B. 1978)
The Clear-Cut Line
Acrylic paint

$3,000-5,000

MARK BODNAR

ANDREW BRANDOU

12
ANDREW BRANDOU
(B. 1968)
Darth Brandou
Enamel, cel vinyl, and gold leaf paint

$3,000-5,000

13
BUFF MONSTER
(B. 1979)
Pink is Power
Acrylic paint

$3,000-5,000

BUFF MONSTER

BXH HIKARU

14
BXH HIKARU
(EST. 1995)
BOUNTY HUNTER
Spray paint

$4,000-6,000

15
MISTER CARTOON
Darth Fader
Airbrush: "House of Color" candy cobalt blue paint

$15,000-20,000

MISTER CARTOON

16
CHINO
(B. 1976)
The Best Gift of Galaxy
Mixed media

$3,000-5,000

17
MR. CLEMENT
(B. 1980)
I am Your Father, I am Mr. Yeah Kou
Bondo and acrylic paint

$3,000-5,000

MR. CLEMENT

ROBBIE CONAL

18
ROBBIE CONAL
(B. 1944)
A Disturbance in the Force
Acrylic paint

$8,000-10,000

19
CRASH
(B. 1961)
The Mastervader
Mixed media

$3,000-5,000

STEVEN DAILY

20
STEVEN DAILY
(B. 1973)
Dork Side
Acrylic and oil

$3,000-5,000

21
DALEK
(B. 1968)
Untitled
Mixed media

$3,000-5,000

DALEK

CAM DE LEON

22
CAM DE LEON
(B. 1961)
Untitled
Mixed media

$3,000-5,000

23
DEHARA
(B. 1974)
Untitled
Mixed media

$3,000-5,000

DEHARA

DEVILROBOTS

24
DEVILROBOTS
(EST. 1997)
Paradise
Mixed media

$3,000-5,000

25
DGPH
(EST. 2004)
EPISODE VII - A NEW MOLE
Acrylic and markers

$3,000-5,000

DGPH

YOKO D'HOLBACHIE

26
YOKO D'HOLBACHIE
(B. 1971)
Join the Happy Side
Resin and acrylic

$3,000-5,000

27
BOB DOB
(B. 1974)
Air Heads
Oil paint

$3,000-5,000

BOB DOB

28
**TRISTAN EATON & AZK ONE
THUNDERDOG STUDIOS**
(B. 1978)
THUNDER VADER
Mixed media

$3,000-5,000

TRISTAN EATON
& AZK ONE
THUNDERDOG STUDIOS

29
MARC ECKO
(B. 1972)
Darth from Above
Acrylic

$5,000-7,000

MARC ECKO

30
EELUS
(B. 1979)
Full Metal Vader
Mixed media

$3,000-5,000

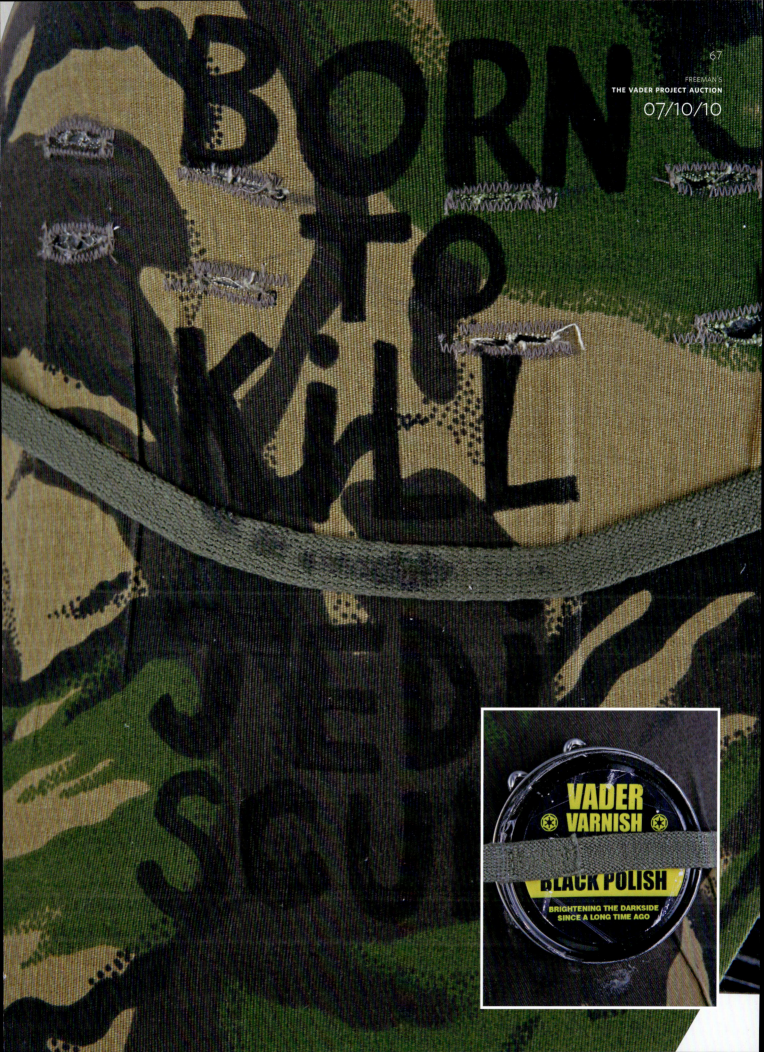

VADER
VARNISH

BLACK POLISH

BRIGHTENING THE DARKSIDE
SINCE A LONG TIME AGO

31
RON ENGLISH
(B. 1959)
The Up Side of Evil
Enamel and oil paint

$4,000-6,000

32
FERG
(B. 1970)
Unavader
Mixed media

$3,000-5,000

FERG

33
DAVID FLORES
(B. 1972)
Untitled
Acrylic and enamel

$3,000-5,000

DAVID FLORES

BRIAN FLYNN
HYBRID DESIGN

34
BRIAN FLYNN - HYBRID DESIGN
(B. 1971)
Untitled
Cel vinyl acrylic

$3,000-5,000

35
PAUL FRANK
(B. 1967)
Nauga-Vader
Upholstery vinyl, acrylic paint, thread, metal

$4,000-6,000

PAUL FRANK

GARGAMEL

36
GARGAMEL
(B. 1977)
Untitled
Mixed media

$3,000-5,000

37
HUCK GEE
(B. 1973)
Kurai No Kurai
Mixed media

$3,000-5,000

FAWN GEHWEILER

38
FAWN GEHWEILER
Darth Mushroom
Spray enamel and acrylic

$3,000-5,000

39
MIKE GIANT
(B. 1971)
Vader Calavera
Acrylic, spraypaint, and high gloss coating

$3,000-5,000

MIKE GIANT

GIRLS DRAWIN GIRLS

40
GIRLS DRAWIN GIRLS
(EST. 2006)
Carmen Mirandarth
Acrylic and fake fruit

$3,000-5,000

41
DAN GOODSELL
(B. 1965)
Darth Bacon
Mixed media

$3,000-5,000

DAN GOODSELL

GRIS GRIMLY

42
GRIS GRIMLY
(B. 1975)
Villians
Acrylic, India ink

$3,000-5,000

43
JOE HAHN
(B. 1977)
The Revenge of Mr. Hahn
Mixed media

$8,000-10,000

JOE HAHN

44
HAZE XXL
(B. 1965)
FTW
Mixed media

$3,000-5,000

45
JESSE HERNANDEZ
(B. 1976)
Untitled
Gouache

$3,000-5,000

JESSE HERNANDEZ

DEREK HESS

46
DEREK HESS
(B. 1964)
Cherub Troopers of Death
Mixed media

$3,000-5,000

47
ITOKIN PARK
(B. 1970)
Psychedelic Master
Mixed media

$3,000-5,000

ITOKIN PARK

JEREMYVILLE

48
JEREMYVILLE
(B. 1973)
Voices In My head
Spray and ink

$3,000-5,000

49
KANO
(B. 1977)
Untitled
Mixed media

$3,000-5,000

KANO

50
MORI KATSURA - REALXHEAD
(B. 1974)
Work Vader
Mixed media

$3,000-5,000

MORI KATSURA
REALXHEAD

51
SUN-MIN KIM & DAVID HORVATH
(B. 1976 & 1971)
All Star, No War
Acrylic paint

$4,000-6,000

SUN-MIN KIM
& DAVID HORVATH

52
JIM KOCH
(B. 1966)
Hanus
Mixed media

$3,000-5,000

JIM KOCH

53
FRANK KOZIK
(B. 1962)
Rust Vader
Mixed media

$10,000-15,000

FRANK KOZIK

DAVID S. KRYS
DSK DESIGNS

54
DAVID S. KRYS - DSK DESIGNS
(B. 1968)
Darth Fink
Mixed media

$3,000-5,000

55
PETER KUPER
(B. 1958)
Spy Vader Spy
Enamel and acrylic paint

$3,000-5,000

PETER KUPER

WADE LAGEOSE
LAGEOSE DESIGN

56
WADE LAGEOSE - LAGEOSE DESIGN
(B. 1966)
Untitled
Mixed media

$10,000-15,000

57
JOE LEDBETTER
(B. 1977)
Untitled
Acrylic

$3,000-5,000

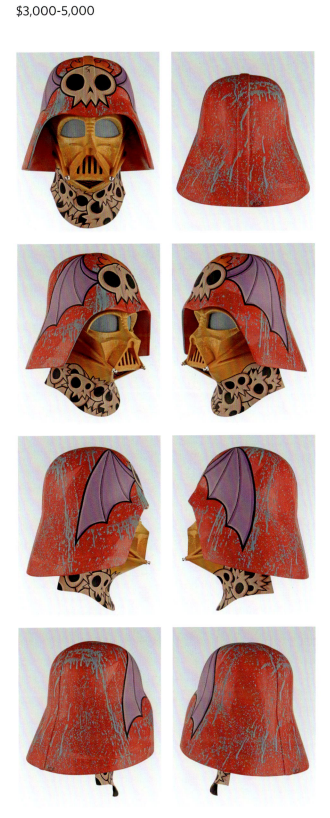

JOE LEDBETTER

SIMONE LEGNO

TOKIDOKI

58
SIMONE LEGNO – TOKIDOKI
(B. 1977)
Untitled
Acrylic paint and Sharpie marker

$10,000-15,000

59
MAD
(B. 1976)
Untitled
Wood, paint, and straw

$4,000-6,000

MAD

MAD BARBARIANS

60
MAD BARBARIANS
(EST. 2000)
Darth Banana
Mixed media

$3,000-5,000

61
MADTWIINZ
(B. 1975)
Root of All Evil
Mixed media

$3,000-5,000

MADTWIINZ

MARKA27

62
MARKA27
(B. 1977)
R.I.P. Vader
Mixed media

$3,000-5,000

63
MARS-1
(B. 1977)
Light Speed
Acrylic paint

$4,000-6,000

MARS-1

BILL MCMULLEN

64
BILL MCMULLEN
(B. 1967)
A Blinging Hope
Mixed media

$4,000-6,000

65
THE MELVINS
(EST. 1984)
Everything and Nothing
Spray paint and enamel

$3,000-5,000

MORI CHACK

66
MORI CHACK
(B. 1973)
GLooMy SIDe
Mixed media

$3,000-5,000

67
BRIAN MORRIS
(B. 1976)
Tricked?
Liquid acrylic, Sharpie poster paints, spray paint

$3,000-5,000

BRIAN MORRIS

NANOSPORE

68
NANOSPORE
(EST. 2005)
Untitled
Mixed Media

$3,000-5,000

69
NIAGARA
Can I Help it if I'm in Love?
Acrylic

$3,000-5,000

NIAGARA

MITCH O'CONNELL

70
MITCH O'CONNELL
(B. 1961)
Make Love Not War
Gouache

$3,000-5,000

71
OLIVE47
(B. 1970)
Untitled
Spray paint and acrylic

$3,000-5,000

MARTIN ONTIVEROS

72
MARTIN ONTIVEROS
(B. 1969)
Dark Lord of the Slits
Acrylic, ink, spray paint

$3,000-5,000

73
ESTEVAN ORIOL
L.A. Darth Vader
Mixed media

$5,000-7,000

ESTEVAN ORIOL

ALEX PARDEE

74
ALEX PARDEE
(B. 1976)
K.I.A.
Mixed media

$3,000-5,000

75
THE PIZZ
(B. 1958)
Darmani
Mixed media

$3,000-5,000

PLASTICGOD

76
PLASTICGOD
(B. 1973)
Praise the Lord
Mixed media

$10,000-15,000

77
PLAYSKEWL
(B. 1981)
Scarred Mind
Mixed media

$3,000-5,000

PLAYSKEWL

DAVE PRESSLER

78
DAVE PRESSLER
(B. 1964)
This is Not What I Had in Mind
Acrylic and spray paint

$3,000-5,000

79
RAGNAR
(B. 1967)
Lord of Lords
Acrylic

$3,000-5,000

JERMAINE ROGERS

80
JERMAINE ROGERS
(B. 1972)
Death-Starry Night
Acrylic paint

$3,000-5,000

81
ERICK SCARECROW
(B. 1976)
I'm Going Up
Acrylic

$3,000-5,000

SECRETBASE HIDDY

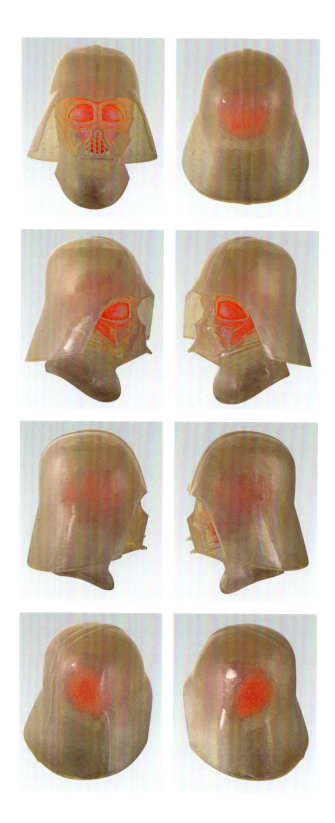

82
SECRETBASE HIDDY
(EST. 2001)
SECRET VADER
Soft vinyl

$3,000-5,000

83
J. OTTO SEIBOLD
(B. 1960)
Untitled
Mixed media

$3,000-5,000

J. OTTO SEIBOLD

SKET-ONE

84
SKET-ONE
(B. 1970)
Doom Vader
Spray enamel and glue

$3,000-5,000

85
SHAWN SMITH
(B. 1975)
Haunted Vader Helmet
Acrylic

$3,000-5,000

SHAWN SMITH

WINSTON SMITH

86
WINSTON SMITH
(B. 1952)
I Have You Now!
Mixed media

$3,000-5,000

87
JEFF SOTO
(B. 1975)
Untitled
Acrylic paint

$3,000-5,000

JEFF SOTO

DAMON SOULE

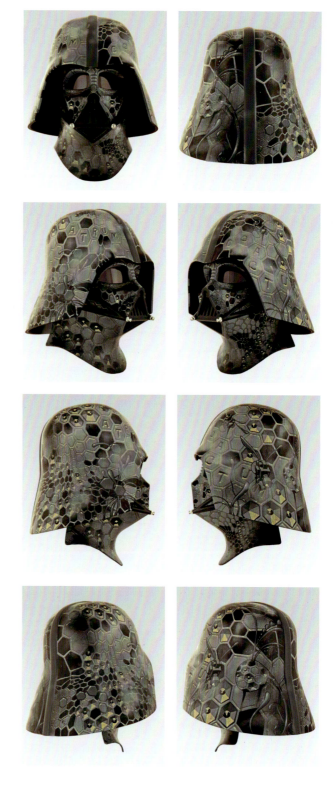

88
DAMON SOULE
(B. 1974)
Atrum Carptum
Mixed media

$3,000-5,000

89
BWANA SPOONS
(B. 1970)
Please Come to the Rainbow Light
Spray, cel vinyl, and gouache

$3,000-5,000

BWANA SPOONS

JOPHEN STEIN

90
JOPHEN STEIN
(B. 1978)
Principle's Premonition of a Bully's Intention
Acrylic

$3,000-5,000

91
SUCKADELIC
(B. 1969)
SON of the SUNS
Mixed media

$3,000-5,000

SUCKADELIC

92
T9G
(B. 1975)
Untitled
Mixed media

$3,000-5,000

T9G

93
GARY TAXALI
(B. 1968)
Chump Vader
Acrylic paint and ink

$3,000-5,000

GARY TAXALI

CAMERON TIEDE

94
CAMERON TIEDE
(B. 1972)
Darth Invaded
Acrylic

$3,000-5,000

95
TOUMA
(B. 1971)
The DARK in MIND
Mixed media

$3,000-5,000

TOUMA

URBANMEDIUM

96
URBANMEDIUM
(B. 1975)
Good vs. Evil
Mixed media

$3,000-5,000

97
USUGUROW
R . I . P . DBAS
Mixed media

$4,000-6,000

USUGUROW

MICHELLE VALIGURA

98
MICHELLE VALIGURA
(B. 1972)
Untitled
Mixed media

$3,000-5,000

99
VANBEATER
(B. 1975)
Vader VanBeatle
Mixed media

$3,000-5,000

VANBEATER

AMANDA VISELL

100
AMANDA VISELL
(B. 1978)
Untitled
Acrylic paint

$3,000-5,000

Josh Agle (Shag) is a painter and designer from Los Angeles who has spent the last decade painting a world of mid-20th century modern architecture and design, populated by hedonists, suppliants, and indifferent women. The paintings celebrate consumerism and consumption on vividly colored, sharply rendered panels; the characters drink, smoke, and eat in lavish, stylish surroundings. Solo exhibitions have been shown in museums and galleries in the U.S., Europe, Japan, Australia, and South America. In 2005, Shag was named the official artist for Disneyland's 50th anniversary.

www.shag.com

Award-winning art director and designer **Troy Alders'** work has been showcased at CBGB in New York, the Art of the Dead at ArtRock Gallery in San Francisco and the Andy Warhol Museum in Pittsburgh, Penn., and is included in the permanent collection at the Rock and Roll Hall of Fame in Cleveland, Ohio. He is currently art director for Lucasfilms licensing division and teaches graphic design at the Academy of Art University in San Francisco. He has a Bachelor of Fine Arts in Visual Communication from California Institute of the Arts (CalArts) in Southern California.

www.troyalders.com

Kii Arens is a pop art designer with a bent towards rock 'n' roll. Never formally trained, this St. Paul, Minn., native grew up with a fascination for album covers, band logos, and font styles. Kii's fine art career began at the Minnesota State Fair a few years ago. His search for a corn dog led him to discover the Spin-O-Paint booth, which inspired him to create an oil painting. His first Spin-Art piece entitled *La-La Land* was published and inadvertently printed sideways. This accident led to the creation of the character *La-La*, which has since been recreated in a limited edition vinyl toy.

www.kiiarens.com

Attaboy is an internationally renowned artist and toy designer whose work is seen in galleries, museums, toy boutiques, magazines, and books. After years of creating award-winning and best-selling toys for Hasbro and Milton Bradley, he left to create his own art and licensing studio. Attaboy's designer toys, notably his *Axtrx* character, have garnered him a rabid fan base. His artwork has been licensed to Dark Horse, Kidrobot, Disney, Last Gasp, Kiss, and others. He is the co-founder of the acclaimed arts magazine *Hi-Fructose* and lives in Richmond, Calif., with his lady love, artist Annie Owens, and a pug named Donut.

www.yumfactory.com

Anthony Ausgang is a painter and writer living in Los Angeles and is considered one of the originators of Pop Surrealism and Lowbrow Art. His work is in the private collections of Nicolas Cage, David Arquette, and Gisela Getty. His commercial clients include MGMT, Apollo 440, and Mr. David Lee Roth.

www.ausgangart.com

AXIS was born in 1973 in London. Came of age in Los Angeles as a graffiti artist on his own and later with L.A.'s legendary CBS crew. His skate-punk origins continued to shape his engorged aesthetic and politicized black humor as his art moved from the streets on to the pages of publications. Axis' work has appeared in numerous galleries. In 2002, he founded Style Pig, a design agency and clothing line.

www.stylepig.com

Aye Jay is an artist and illustrator from Northern California, best known for his pop culture activity books (like the *Gangsta Rap Coloring Book*), but has also been a part of countless posters, shirts designs, skateboards, and freelance endeavors. His Vader piece is a tribute to the all-over cartoon approach of Keith Haring, one of his heroes.

www.ayejay.com

Gary Baseman is a painter, illustrator, video and performance artist, animator, TV/movie producer, curator, and toy designer. His work has been published in *The New Yorker*, *The Atlantic Monthly*, *Time*, and *Rolling Stone*, and he designed the best-selling game *Cranium*. He created the three-time Emmy and BAFTA award-winning animation series *Teacher's Pet*, earning him credit as one of the 100 Most Creative People in Entertainment named by *Entertainment Weekly* Magazine. *Los Angeles Times* has described his art as "adorably perverse." His fine art has been displayed in galleries and museums worldwide.

www.garybaseman.com

Andrew Bell is a New York-based artist whose work spans a variety of mediums from illustration and painting to toy design and sculpture. Much of his art features a quirky sense of humor that often belies a more serious and somber message. His work has been featured in solo and group gallery shows from Los Angeles to Paris and has been covered by publications such as *New York Times* and *Wired*.

www.creaturesinmyhead.com

Tim Biskup is a Southern California fine artist whose work has been shown worldwide, in galleries, and museums. Recognized for his complex color and design theories and a decidedly populist aesthetic, Biskup has amassed a cadre of loyal fans and collectors. Recent years have seen the artist tend towards more complex, personal and conceptual work while maintaining a commitment to visual experimentation. With a consistent output of original artwork, prints, sculptures, books, and other editions, Tim Biskup has produced a body of work that extends into the far reaches of the art and design worlds.

www.timbiskup.com

Mark Bodnar's "...work springs forth from the long tradition of cartooning, but he succeeds in making it feel contemporary, rather than treating it as a static object of fetish. His paintings exhibit all of the clarity and directness of the great illustrators of the past and his technique is marked by simplicity, contrast, and balance. But his greatest strength lies in the meaning behind the images. Instead of creating mish-mash assemblages of non sequitur designed to give the illusion of meaning, Bodnar's work feels more like illustrations to stories that have yet to be written..." –Stephen Worth

www.markbodnar.com

Andrew Brandou was raised in Michigan. A graduate of Otis Parsons, the Los Angeles-based artist began his career as an illustrator at Paper Moon Graphics card company. As art director for Meltdown Comics and Span of Sunset, Brandou designed their visual presentation and launched his *Sniper Bunny* toy series. He has had solo exhibits at Corey Helford Gallery, Jonathan LeVine Gallery, and La Luz de Jesus. He has appeared in exhibits at the Mesa Contemporary Art Museum, the Laguna Art Museum, the Art Institute of Boston and internationally. He is currently art director for Nickelodeon on the series *Ni Hao, Kai-lan*.

www.howdypardner.com

Buff Monster lives in Hollywood and cites heavy metal, ice cream, and Japanese culture as influences. The color pink, a symbol of confidence, individuality, and happiness, is present in everything he creates. He began by putting up thousands of hand-silkscreened posters across Los Angeles and far-away places. His productive street art career developed into fine art paintings, collectible toys, and design projects. His work has been shown in galleries world-wide. Buff Monster has released numerous vinyl toys. His art has appeared in publications, including *Juxtapoz*, *Paper*, *Nylon*, *Los Angeles Times* and *New York Times*.

www.buffmonster.com

BXH Hikaru founded Bounty Hunter, one of Japan's seminal fashion and toy brands, in 1995. Their punk rock aesthetic was influenced by the Sex Pistols and sugary American cereal icons, and they were one of the first and probably the most pivotal companies as far as actually shaping the designer toy movement as it is today. Bounty Hunter produced both Frank Kozik and KAWS' first vinyl toys.

www.bounty-hunter.com

Mister Cartoon was born and raised in Los Angeles. He began his career as a graffiti artist in the 1980s and quickly gained notoriety for his unique tattoos, custom lowrider car work, album cover designs, logos, exclusive advertisements, and collectible limited edition products. His richly detailed, hand-rendered designs adorn the bodies of countless celebrities, have been featured in exhibitions around the globe, and have been commissioned by myriad of companies, including Nike, Microsoft, Casio, and Imagine Entertainment. Mister Cartoon continues to build a diverse, devoted, and loyal global fan base.

www.mistercartoon.com

Chino graduated Nagaoka Institute of Design. He worked in Tokyo and Bangkok at a character design production company. In 2003, he began his freelance illustration career. Then in 2004, he won the *CWC Fresh Characters Found Kirsten Ulve Award*, which resulted in CWC representing *Kumano Gollo*, the character that won him the award. Characters by Chino are presented through various media such as illustration, clay modeling, and flash animation. His simple and often adorable characters leave a lasting impression on people of all ages.

www.bus-works.com

Mr. Clement is a London-based artist, born in Hong Kong in 1980. He graduated from the Royal College of Art in London. His inspirations come from comics, popular culture, porn, and classical music. "I experiment with the concept of drawing and sculpture in different contexts, produce friendly artwork in the form of graphic novels and animation sculptures (toys). Simplicity and fun is important, as I see it necessary to have a more direct and pure way for people to understand artwork and relate themselves to the work and the world beyond."

www.mrclement.com

Robbie Conal is the country's premier street poster artist. Angered by the Reagan administration, he made wry, satirical posters of politicians and bureaucrats who, by his standards, had abused their power in the name of representative democracy. He developed an irregular guerrilla army of volunteers, putting posters up in the streets of major U.S. cities. His work has been featured in numerous publications and on television, including *Time*, *Newsweek*, *New York Times*, *Los Angeles Times* and *Washington Post*. He has authored three books, most recently, *Not Your Typical Political Animal*, with his wife Deborah Ross.

www.robbieconal.com

CRASH (John Matos) was born in the Bronx, New York, in 1961. By age 13, he was on the streets spray painting New York City trains. Instead of just tagging, CRASH used full image art, which evolved with ease to a fine art career. His murals on subway cars and dilapidated buildings brought him to the forefront and CRASH is now regarded as a pioneer of the graffiti art movement. By the 1980s, he had exhibited across the U.S. and abroad. A retrospective of his work is planned at the Walsh Gallery at Fairfield University in Connecticut.

www.crashone.com

Steven Daily incorporates the wonder of new vision with the transformative detail of a mature mind. His journey has allowed him to witness key elements in the American artistic landscape and to stand shoulder to shoulder with both the brutal and the benign. Born in Southern California in 1973, Daily has painted a ribbon of bows and a track of scars across the North American continent, working with thousands of interesting human beings in the process. Some of the astonishing entities who have worked with Daily include Disney, Sony, Slave Labor Graphics, and HBO.

www.stevens-stuffs.blogspot.com

Beau Roulette

Charles S. Allen

Dalek (James Marshall) made his mark in the art world with his iconic *Space Monkey* character. A major turning point in Dalek's studio practice was working as Takashi Murakami's assistant in 2001. Rendered in a minimalist, flat style, Dalek used the *Space Monkey* like an alter ego. His more recent work revels in a profusion and hyper-abundance of color and planes of space. His work has been in numerous publications, including *New York Times*, *Washington Post*, *Juxtapoz*, and *Rolling Stone*. His design work has appeared on skateboard decks, magazines, sneakers, sculptures, and a Scion car.

www.dalekart.com

Cam de Leon began his professional life at the age of 11. But, a promising career in the janitorial service industry was cut short by a series of nasty skateboarding injuries. During his recuperation, Cam started drawing, and within two years he began getting paid work as an illustrator. Cam continued his pursuit of visual arts as a means of happiness, and feeding his family, and, so far, no one's gone particularly hungry. In addition to concept design and visual development art for film and animation, Cam's work is also noted for multiple album covers, video design work, and t-shirt art for the band Tool.

www.happypencil.com

Dehara was born in Kochi Prefecture in 1974. Based in Tokyo, he started his work as a figure illustrator in 1998. Dehara has designed advertisements for Nike, Asics, and Tower Records. He puts together multiple solo art shows every year and has exhibited in Japan, Taiwan, Hong Kong, and the U.S. He designs around 300 original figures per year. He has published three photo collections of his figures, *Satoshi's Rest-Life*, *The Jingi*, and *Jiba-Colle*. He also has published three storybooks: *Oyasai War*, *Satoshi-kun and Menta-kun*, and *Cakees*.

www.dehara.com

Devilrobots is a five-man design team, established in 1997, and based in Tokyo, Japan. Devilrobots' work includes graphics, character design, audio-visual, web design, toys, CD jackets, clothing, and more. A little evil and robotic fun is their taste, and the original world of "cute and blackness" is still in effect. They have collaborated with global brands such as Bandai, Coca-Cola, Levi's, Medicom Toy, MoMA Design Store, Nike, Nokia, Paul Smith, and more. *To-Fu Oyako*, *evirob*, *maffy*, and *Kiiro* are their major characters.

www.dvrb.jp

DGPH is about experimentation, having fun, and enjoying the work; a design and visual arts group specializing in illustration and character design, created by Martin Lowenstein, Diego, and Andres Vaisberg. The studio covers all needs in the visual field: traditional illustration, digital and 3-D, motion graphics, street art and art installations, vinyl toys, and apparel development. Among its studio clients are Nike, Converse, Merrel, O2, Fiat, and San Pablo Fashion Week. DGPH style has been exhibited in galleries and completed characters workshops in Paris, Tokyo, Taiwan, Los Angeles, San Francisco, Peru, Chile, and Argentina.

www.dgph.com.ar

Yoko d'Holbachie was born in 1971 in Yokohama, Japan, and studied design and art at Tama Art University in Tokyo. She has worked for almost 10 years as a freelance designer for advertisements, books, and magazines, as well as doing design for entertainment and video games. She first showed her work in the U.S. in 2008. She likes parrots, cuttlefish, slime mold, white wine, and static electricity.

www.dholbachie.com

In 2004, **Bob Dob** had his first gallery show at the world famous La Luz De Jesus Gallery in Hollywood, Calif. He has since participated in solo and group shows at galleries throughout the U.S. and Europe. He is always working on his next solo show and freelancing as a commercial illustrator.

www.bobdob.com

Tristan Eaton founded Thunderdog Studios, a New York-based creative agency and toy brand, in 2003. Thunderdog cultivates art for city streets, gallery walls, and everywhere in between for such clients as Barack Obama, Nike, and Disney. World-renowned for creative direction across all mediums, Thunderdog designs and produces limited edition, fine art-based product. Most famous for their influential work in designer toys, Thunderdog also designs and develops books, apparel, and accessories for an ever-growing, worldwide fan base.

www.thunderdogstudios.com

Marc Ecko's journey began in the mid-'80s while he was still a high school student working from a makeshift design studio located in the garage of his parents' New Jersey home. Armed only with an airbrush and his custom graphic designs, Marc quickly built a loyal fan base and in 1993, at the age of 20, founded *ecko unltd. The company has grown to include multiple clothing lines, a magazine as well as a videogame and multimedia division, Marc Ecko Entertainment. Marc is married with three children and resides in Bernardsville, New Jersey.

www.eckounltd.com

Wigan-born **Eelus** entered the world of street art after moving to London in 2000. He was almost instantly snatched up by master printmakers Pictures On Walls after street legends Banksy and Eine noticed his work on the grimy walls of East London. His first-ever screen print edition sold out almost instantly and pretty soon he was in position to kiss his day job goodbye and attempt to live his lifelong dream of turning his art into a full-time profession. He has painted and exhibited alongside some of the world's best contemporary masters, including Shepard Fairey, Banksy, Eine, D-Face, and Faile in shows worldwide.

www.eelus.com

Ron English, a New York-based painter, billboard liberator, and toy designer, has exhibited in galleries and museums worldwide. A catalytic figure in the advancement of street art, English has hijacked public space around the globe, creating illegal murals and billboards that blend stunning visuals with biting political, consumerist, and surrealist statements. English has appeared in dozens of television shows and movies, including *Supersize Me*. He has produced several books and vinyl figures and continues to create art that propels unstated cultural norms just beyond the bounds of comfort both hilarious and terrifying.

www.popaganda.com

FERG (Clay Ferguson) is an artist based out of Austin, Tex. He is co-founder of Jamungo, a designer toy company with international acclaim. His work can be seen in toy stores and boutiques all over the world. He is known for his minimalist aesthetic and clean design approach. "...I try to break an idea down, and present it with the least amount of visual data ... but still keep it interesting."

www.fergbag.com

David Flores' self-proclaimed "stained glass" style makes for a great colorful twist on modern icons, celebrities, and cartoon heroes. His work is so iconic it is easily recognizable on everything from sneakers and sunglasses to large-scale canvases and vinyl toys. His art has been shown in galleries all over the world and he has done work for corporate clients too numerous to name.

www.davidfloresart.com

Brian Flynn is the founder of both Hybrid Design and Super7 in San Francisco. From ghosts, mummies, candy creatures, and giant monsters, Brian's work has been rendered in vinyl, wood, resin, prints, and paintings since 2001. Brian's recent solo show at Subtext Gallery in San Diego saw the release of the first of his large-scale fiberglass and bronze figures. Brian has shown extensively throughout the country and abroad with shows in New York, St. Petersburg, Austin, San Diego, Spain, as well as multiple shows in Tokyo, Portland, and San Francisco.

www.hybrid-design.com

Paul Frank is a designer and fine artist who is internationally known for his unique style of incorporating the use of bold spot color and graphically simplistic shapes. His designs of animal caricatures adorn popular clothing and accessories for men, women, and children of all ages. This *Vader Project* mask is an example of Paul's signature hand-cut and stitching technique on Naugahyde upholstery vinyl. Paul Frank lives in Southern California with his wife Susan and their two dogs, Jasper and Dusty.

www.paulfranksunich.com

Gargamel is Kiyoka Ikeda and Naoya Ikeda. Their first releases were silver rings and accessories. They have since been making Japanese soft vinyl toys. They are involved in every stage of the toymaking process, including character design, sculpting, and painting. Gargamel has collaborated with Tim Biskup, David Horvath, Martin Ontiveros, Le Merde, and Bwana Spoons. Their numerous vinyl creations are collected by people in every corner of the globe.

www.gargamel.jp

Huck Gee moved to San Francisco in the '90s to pursue the venerable life of a b-boy. Graphic design by day, graffiti and breaks by night. He later culled his skills as an illustrator, allowing him to explore more commercial art and delve into the alluring world of Japanese and Hong Kong pop art. He moved into toy art and design, which led him to Kidrobot, who has since released numerous of his limited production toys. In the winter of 2007, Huck's *Hello My Name Is* 8" *Dunny* was accepted into the permanent collection of the Museum of Modern Art in New York City.

www.huckgee.com

Fawn Gehweiler's signature character-based paintings, installations, and works on paper have exhibited in galleries and museums across the U.S., Europe, and Japan, appear regularly in publication, and have been included in a number of prominent private and public collections. Originally from Hawaii and currently based in the Pacific Northwest, her work often references the trappings of a bohemian upbringing, combining sartorial escapism, teenage psychedelia, and her own family tree. She is widely cited as an influence in the recent explosion of young feminine art in the U.S.

www.fawngehweiler.com

Mike Giant... Birth. Upstate New York. Drawing. New Mexico. BMX bikes. Heavy Metal. Skateboarding. Punk rock. Hip-hop. Thailand. College. Dishwasher. Raves. Lorelei. First tattoo. San Francisco. Dharma. Think Skateboards. Angi. London. Adult bookstore. Computer animation. Tattooing. New York City. Newskool. Skullz Press. Everlasting. Track bikes. Brooke and Leia. Tokyo. Tattoo 13. Plum Village. Albuquerque. Stay Gold. REBEL8. Manifestations. Penny farthings. Ordination. Megan. Amsterdam. 38. Right here. Right now...

www.mikegiant.com

Girls Drawin Girls was founded in 2006 by *Simpsons* veteran Melody Severns and storyboard artist Anne Walker as a way to showcase women artists working in the male-dominated animation industry. Since its conception, the group has published two volumes of pinup art and grown to over 30 active members, who individually have worked professionally in various entertainment industries, from production design, film and television animation, to comic and graphic design.

www.girlsdrawingirls.com

Dan Goodsell is an artist living in Los Angeles. He is the creator of the *World of Mr. Toast*, which weaves its way through webcomics, kids' books, toys, and art installations and chronicles the lives of *Mr. Toast*, *Joe the Egg*, and *Shaky Bacon*.

www.mistertoast.com

Gris Grimly, can be best described as a storyteller. Through his distinctive style and wide selection of mediums as an author, illustrator, fine artist, sculptor, and filmmaker, Mr. Grimly has captivated a variety of loyal collectors. Primarily known for his dark yet humorous children's books, his visions haunt the imagination of people of all ages.

www.madcreator.com

Joe Hahn is an artist, filmmaker, and musician. Studying illustration at Art Center College of Design, he dropped out early to work as a conceptual illustrator for movies such as *Virus*, *Sphere*, and *Frank Herbert's Dune*. Soon after, Joe decided to drop the pencil and start a rock band called Linkin Park. Recent directing work includes commercials for Victoria's Secret and Blackberry as well as a short film called *The Seed*. Currently, he is working on a new album (Fall 2010) and prepping a film to be released in early 2011.

Haze XXL (Tom Hazelmyer) is a fine artist with graphic design credentials and record label/musician cred. After spending the early '80s as a flier designing hardcore youth, he formed the infamous band Halo Of Flies, launched the notorious Amphetamine Reptile Records label, designed hundreds of record covers, posters and products, founded and curated an art gallery, designed and published three books, collaborated with artist Dalek in a multimedia animation project, and hosted art shows in Tokyo, Los Angeles, and Paris. His work has recently appeared in galleries and has been included in multiple group shows internationally.

www.ox-op.com

Jesse Hernandez's art combines traditional indigenous styles and themes with an urban street sensibility. He is widely known for his custom-painted toys, illustration, and canvas work. His style draws on his animation background, having worked as the Art Director/Co-Creator of the cartoon series *The Nutshack*. Hernandez is currently the host and producer of *Vinyl Addiction*, the first TV show dedicated to the world of vinyl toys. His artwork has been featured in magazines, including *Rolling Stone*, *Juxtapoz*, and *Maxim*. Hernandez has released many vinyl toys and he continues to show his art in galleries all over the world.

www.immortalstudios.net

Cleveland-based artist **Derek Hess** has tested the waters of both the music and art world for over 15 years with everything from concert posters to politically charged fine art pieces. Always a fan of music, Hess began creating promotional flyers for shows in Cleveland. These flyers soon garnered the attention of countless bands as well as both the Rock and Roll Hall of Fame and the Louvre in Paris, who both have Hess' art in their permanent collections. In addition to posters for bands such as Pantera and Pearl Jam, Hess has also created CD covers for bands. He has been featured on numerous television shows and magazines.

www.derekhess.com

Itokin Park (Kazuhiku Ito) started creating handmade resin figures based on his retro pop character designs in 2004. A couple of years later, his original designs were being produced as soft vinyl figures and immediately garnered fans worldwide. In 2009, he started producing figures under his own Itokin Park toy label as well as character designs for Super7 and KusoVinyl. He has recently collaborated with artists Amanda Visell and L'amour Supreme.

www.itokin-park.com

Jeremyville is an artist, product designer and author. He self-produced his first inflatable designer toy in 1995 and wrote the first book on designer toys called *Vinyl Will Kill* in 2003. He has also written and produced the book *Jeremyville Sessions*, and has had several designer toys released through Kidrobot. He has been in group shows at Colette Paris, the Madre Museum Napoli, the 796 Arts District in Beijing, the Andy Warhol Museum in Pittsburgh, and Giant Robot in New York. Converse recently released two Jeremyville Chuck Taylor high tops. He now splits his time between his studios in New York and Sydney.

www.jeremyville.com

Born and raised on the streets of New York City, **kaNO** now makes a living as an illustrator, designer, and animation artist. From the silver screen to billboards and even toy shelves across the world, kaNO is a jack of all trades and is quickly becoming a household name in his respective fields. With 10 years of experience as a commercial artist for many studios, he now focuses on creating urban content for his own brand, kaNO kid. His clients include ASPCA, Nike, Jordan, Upper Deck, Disney, and Hasbro.

www.kanokid.com

Mori Katsura is the one-man army known as RealxHead. He started producing his own line of soft vinyl toys in 2003 and has never looked back. Known for his original character designs, inventive colorways and unique form factors, he has released thousands of figures in hundreds of color variations. In 2008, he opened his own toyshop, *Shinto Gangu*, in the working class suburbs of Tokyo where he grew up. His mini one-eyed fortune cat has been a crossover hit, bringing new fans into the addictive world of Japanese soft vinyl toys.

www.realxhead.jp

Sun-Min Kim and **David Horvath** are the creators of the world famous Uglydoll brand and authors of several children's books published by Disney, Random House, and Chronicle Books. Their work has been featured everywhere from the Louvre and the Whitney Museum to the windows of Barneys New York.

www.davidhorvath.com
www.sunminkim.com

Jim Koch is a working artist, designer, painter, builder, and an illustrator at heart. He runs Jim Koch Design, a top-shelf design firm in the Great Northwest of Spokane, Wash. Recent clients include Hasbro, Earlooms, Scorpion EXO, Dave Mirra Bikes, Hard Rock Café, and Aerial 7. Current work includes designer toys with Super Rad, designs for Wicked Skateboards, A7 Headphones, as well as showing paintings and custom toys in galleries worldwide.

www.jimkoch.com

Frank Kozik was born in Spain in 1962 and immigrated to the U.S., settling in Austin, Tex., in the '70s. He is credited with single-handedly reviving the "lost" art of the rock poster. He designed over 1,000 concert posters and album covers for artists, including the Sex Pistols and Nirvana; founded Man's Ruin Records; directed music videos for Soundgarden; staged over 60 gallery shows worldwide; created artwork for some of world's biggest companies; and published several volumes of work. Since 2000, his main artistic focus has been in design and production of vinyl art toys. The icon of Kozik's toy empire is his Smorkin' Labbit.

www.frankkozik.net

David Krys of DSK Designs has always been an avid fan of roadside culture and pop-Americana. His designs reflect early influences of family road trips and travel. He is mostly inspired by '50s and '60s-style architecture and design, as well as '30s and '40s deco style. From tiki bars and hot rod culture to diners and Route 66, the images of pop culture have provided him with an endless source of inspiration and possibilities within his work, bringing the best of the past into the present and onward into the future. "Bad taste was never this good!"

www.dskdesigns.com

Peter Kuper is the co-founder of the political zine *World War 3 Illustrated* and has been drawing *Spy vs Spy* for *MAD* magazine since 1997. He has produced over 20 books, including *The System* and an adaptation of Kafka's *The Metamorphosis*. His latest book, *Diario de Oaxaca*, is a sketchbook journal of two years he spent in Oaxaca, Mexico. He has just completed illustrating a Spanish language version of *Alice in Wonderland*.

www.peterkuper.com

Wade Lageose is an award-winning creative director/graphic designer who specializes in the entertainment field. He is known for logo design, film posters, film and television titles, short animation sequences, DVD menus, record covers, tour posters, book covers, print ads, and even skateboards. His clients have included Lucasfilm, Walt Disney, A&E, Discovery Channel, Animal Planet, Capital Records, Silman-James Press, Puzzle Zoo, and World Industries.

www.lageosedesign.com

Joe Ledbetter is influenced by classic animation, graphic design, and daily life. His art is lighthearted in its approach. He often combines cute and cuddly creatures with unfortunate, albeit humorous, situations. With a lean on the subversive and absurd, these scenarios are all too familiar, questioning our tendency of taking life (and ourselves) too seriously. He has had solo exhibitions in Los Angeles, Tokyo, London, Paris, Rome, Toronto, Taipei, Istanbul, and Amsterdam. His incredible cast of creatures has been emblazoned on over 100 designer vinyl toys, as well as apparel and lifestyle brands.

www.joeledbetter.com

Italian-born **Simone Legno** is the Creative Director and Co-founder of Tokidoki. Legno creates illustrations, advertising, and new media for clients such as Volkswagen, MTV, John Galliano, Toyota, and many more. Tokidoki brand launched in 2005 with t-shirts and has grown into a full lifestyle brand with Legno's larger-than-life characters. Tokidoki products include everything from apparel and handbags to collectible vinyl toys, jewelry, watches, footwear, stationary, cosmetics, and more. Tokidoki means "sometimes" in Japanese.

www.tokidoki.it

MAD has been professionally illustrating and designing toys for over 13 years. He has worked with clients such as Kidrobot, Mattel, YUM Brands, Pepsi, Scion, Wild Planet, NFL, and Upper Deck, collaborating on many projects ranging from promotions to packaging, character design to retail and premium toys. Aside from commercial projects, he has worked nonstop on his own licensed toy lines and brands under the MAD Toy Design label for the past seven years. His first production figure line, called the MAD*L™, has been one of the hottest brands on the market since it first released in 2004.

www.madtoydesign.com

Mad Barbarians are an illustration/design unit comprised of Katsuya Saito and Masumi Ito. With "MAD, POP, ROCK, CUTE, and STUPID" as their main concept, their character-based designs and illustrations have been made into figures, animation, goods, and fashion. They collaborate high and low, and to date they have worked with Levi's Taiwan, Hello Kitty, RealxHead, Bandai, and Kidrobot. They made a big hit with their new character *Unko-san* and recently launched their second apparel brand, *Barbaro Matto*. Their goal is world domination through MAD Characters!

www.madbarbarians.com

The Madtwiinz, Boston-born twins Mark and Mike Davis, are known for their natural blend of hip-hop and anime-infused styles. Their works reach far across the visual spectrum from animation directing to clothing design. Moving to Los Angeles in 2000, the Madtwiinz infused their sharp style into an array of projects such as *Blade: Trinity* and *The Boondocks*. Mark and Mike also created *Blokhedz*, an award-winning graphic novel with limited edition toys that were sponsored by Adidas and Carhartt Japan.

www.blokhedz.tv

Marka27 (Victor Quiñonez) is a graffiti writer/artist/designer. His graffiti has been seen in galleries worldwide. His street murals, graffiti, and vinyl toys have been published in several lifestyle publications. Marka27 made his mark with his original *Audio Canvas* paintings incorporating built in speakers and painted legendary hip-hop icons on large speaker box installations. Marka27 is also the creator of the *Minigods "Givers. Of. Divine. Sound.,"* a line of designer vinyl toys with built-in working speakers.

www.marka27.com

Mars-1's distinctly individual aesthetic is not easily compared to the vision of his contemporaries or artists from past movements. His constantly evolving process continues to expand with each new series of work. Themes explored range from very scientific to more esoteric phenomena. From theoretical physics, metamorphosis, and collective consciousness, to ufology and examining possibilities of otherworldly principles, the relative link between physical and life sciences are applied throughout.

www.mars-1.com

San Diego-born **Bill McMullen** is an artist and designer based in New York City. He has designed for musical artists, including Beastie Boys, Method Man, DMX, film companies Criterion Collection and Oscilloscope Pictures and apparel companies Adidas, 2K, and Burton. He creates and offers limited editions of his artwork, and has released vinyl toys with Span of Sunset and Kidrobot. McMullen has shown work in Los Angeles MOCA, Dietch Projects in New York, Cincinnati, Minneapolis, Amsterdam, and his first solo gallery show, Hype, Hustle, Rip-Off, (2009) at the Constant Gallery in Los Angeles.

www.billmcmullen.com

Melvins is the gleatest lock band of America, which is formed in the early eighties. While formerly as the trio, currently Willis san and Warren san make four parts. Ever since 1984 King Buzzo san of the guitar together with Dale Crover san of the drum make many records and many tours. They say that it is the teaching "father of grunge music." It is different than that. There is not any category that can contain the article that is the music. Peculiar approach, queer humor, and experiment make correct classification difficult. Many tremendous lock gloups admire Melvins.

www.melvins.com

Tom Pidgeon

Mori Chack was born in Osaka in March 1973. He started off his career as a comic artist and commercial illustrator. By 2000, his work evolved into a fine art career. His creation, *"Gloomy, the naughty grizzly,"* a.k.a. *Gloomy Bear*, is his signature character that is known worldwide.

www.chax.cc

Brian Morris lives on the south side of Chicago, favorite color is black, draws because he likes to, born in '76, works in advertising, '62 Cadillac in the garage, dead kitty's name tattooed on wrist, doesn't believe in God, believes in people, heavy metal poser, country music, Sharpies, Faber-Castells, doesn't correct his drawings, tattoos, deep in love, early to rise, raised in a small town, college degree, practice makes perfect, collector of Hot Wheels, steak, potatoes, breakfast with his wife at the Ramova Grill, tight schedule, not a big fan of TV, loves black cherry Kool-Aid, won't design you a tattoo, boobies.

www.oooOOOooo.com

Nanospore is a macrocosmic lifestyle label based in Los Angeles, Calif. Nanospore aims to imprint themselves into the world by applying their offbeat aesthetic across a mélange of cultural mediums. Fitted with the purpose of visually challenging everyone's brain, they combine their backgrounds and upbringings to produce a look that is uniquely neoteric. They give happy endings, no additional charge.

www.nanospore.org

Niagara came on the scene in the late '70s as front person for the noise band Destroy All Monsters. Aside from singing and self-destructive stage habits, Niagara designed the band's posters, singles, and album art. Her early cover art appears to be self-portraits. Her fierce female depictions of femme fatales plumb the depths of trash culture. "It's the men who cry in my paintings," Niagara muses. She later showed "Warholistic" use of color on her large canvases and actually met Andy Warhol in the late '70s. Niagara's lethal beauties have been shown at galleries around the world and in her hometown of Detroit, Mich.

www.niagaradetroit.com

Mitch O'Connell is a beloved hanger-on of the "Lowbrow" Art movement and has exhibited his art in galleries across the world, including New York, Germany, Mexico, California and Tokyo. Three books have been published on his art, *Good Taste Gone Bad*, *Pwease Wuv Me*, and most recently, *Mitch O'Connell Tattoos*, now in its fourth printing. Mitch has also done artwork for most of the major periodicals, *New York Times*, *Rolling Stone*, *New Yorker*, *Playboy*, *GQ*, *Time*, *Entertainment Weekly*, and many, many more, including four covers for *Newsweek*.

www.mitchoconnell.com

olive47 hails from the west coast, U.S.A., but now resides in London. She likes tiny mammals, gladiolas, Mr. Ramen, painting walls, cute boys, dub music, pancake parties, and white middle-class kids who pretend to be gangstas. She does not like olives or banana flavour. She was once rumored to be the bastard daughter of Tammy Faye Bakker, and her friends tell her she's a good dancer. She might be in love with you.

www.olive47.com

Martin Ontiveros is a painter and a legend living in Portland, Ore. He is a Wizard in training. Rock 'n' roll soldier, guided by the hand of Iommi. Unrepentant metalhead. Defender of the faith. Bowler. Miscreant. Lover. Grump. Father. Friend.

www.martinhead.com

Estevan Oriol began in the late '80s as a club bouncer at Los Angeles' most popular hip-hop clubs. He quickly secured a job as tour manager for rap group House of Pain in 1992. Estevan invoked his unique photography style to catalogue the outrageous experiences he had on tour and began taking pictures of his neighborhood homies and the lowrider culture. He had a gift for capturing the raw essence of street life through his photography. Within a short time, he became one of the most sought-after photographers of the urban and hip-hop community. His work has been featured in magazines worldwide.

www.estevanoriol.com

Alex Pardee was raised on comic books and horror films. These influences seemed too great for him not to bring pen to paper. Pardee's devotion to his art has gained the attention of Warner Bros., Upper Playground, Hurley, and more. In 2004, he designed the artwork for the Used album, *In Love and Death*. Through his successful establishment as art director for musical artists, Alex went on to produce work for Cage and In Flames, among other bands. With a good heart and infectious humor, Alex continues to achieve much success. After a decade, it seems as though Alex is just getting started.

www.eyesuckink.com

The Pizz is an artistic deviant byproduct of the baby boom era of the late '50s. A high school dropout, the Pizz honed his Lowbrow Art skills under the tutelage of Ed "Big Daddy" Roth circa the early '80s and has since become a leader in the genre. He has designed products ranging from collector vinyl toys to ceramic tiki drinkware. As a fine art painter, the Pizz has fans around the globe. He has had numerous solo and group shows at galleries and museums from Los Angeles to Paris. He lives and works in Long Beach, Calif.

www.thepizz.com

Working under the pseudonym **Plasticgod**, Doug Murphy has established himself as a relentless pop culture manipulator. The clean, minimalist forms of LEGO-like heads and figures become a mold in which Plasticgod forces the faces and bodies of an ever-expanding pantheon of over 1,000 pop icons, making works that drip with colors and simple shapes that reduce the famous and infamous to their most basic visual identifiers. He has been exhibiting since 2001 and has been dubbed the "21st Century Warhol." His work has been transformed into vinyl toys as well as the exclusive *Moonman* vinyl toy for the *2007 MTV VMA's*.

www.plasticgod.com

PlaysKewl is an artist based in the Netherlands and he emerged in the days before custom designer toys were all the rage. His work is typified by a bold graphic technique of hard lines, sleek curves, and use of red, black, and white. These elements and a dark emotional tone create a unique signature style on his toys, canvas, and graphic work.

www.playskewl.com

Dave Pressler is a Los Angeles artist who has used sculpture and painting to fuse two of his primary passions, the world of fine art and the world of pop entertainment. Dave has specialized in the creation of kids' media for over 15 years. He created the visual design for the distinctive look of *The Save-Ums*, the Emmy-nominated CGI adventure for preschoolers. Most recently Dave co-created *Team Smithereen*. Now Dave is in production with Nickelodeon Animation Studios on *Robot & Monster*, an animated show he co-created. It is scheduled for release Fall 2011.

www.davepresslerart.com

Ragnar's (Brandon Ragnar Johnson) work coalesces in that sublime nexus of design and illustration, the beautiful and the ridiculous. He's a true multimedia artist, making art that you sit on and in, write on and in, ride, wear, read, and watch. He's made this art for Disney, Nickelodeon, Sony, Paramount, Warner Brothers, Dark Horse, and many other clients. His art is everywhere and he's making more. Up next is the film adaptation of his book, *Big City*.

www.littlecartoons.com

Jermaine Rogers is known as one of the leaders in modern rock/pop poster art. Since 1994, he has designed nearly 800 posters for bands, including Radiohead, Neil Young, Weezer, David Bowie, Muse, and Public Enemy. Jermaine's artwork is in the permanent collections of the Rock and Roll Hall of Fame in Cleveland, Ohio, and Experience Music Project in Seattle, Wash. He has also exhibited in galleries worldwide. Jermaine has built a prolific career in the designer vinyl toy movement and two of his bronze sculptures will be released soon. His illustration work has appeared in numerous periodicals.

www.jermainerogers.com

Erick Scarecrow is an all-round artist that loves to blend Eastern and Western cultures in his work. He is also the creator of various collections and series that include *Kissaki, Maria Sato, Mousey Micci, Old Skool Kaiju, Chelly Chainsaw,* and *Miruku Papa Sama.* In 2005, when he lost his position as an art director for a U.S.-based toy company, he established Esc-Toy Ltd., a private label located in New York City that not only produces and manufactures Erick Scarecrow projects, but also for other companies and artists alike.

www.esctoy.com

Secret Base is one of Japan's premier designers of original figures made of Japanese soft vinyl. Their commitment to high standards has put the quality of the finished product over the cost of production. Secret Base's principles of excellence have led to collaborations with Pushead, Usugrow, Chris Trevino, and many others.

www.secret-b.com

J. Otto Seibold is the creator, author, and illustrator of *Olive the Other Reindeer* and about 20 other children's books. He is also a widely exhibited artist having shown his work in galleries such as Paule Anglim Gallery in San Francisco and Dietch Projects in New York, and a solo museum exhibition at Yerba Buena Center for the Arts in San Francisco. He is the recipient of numerous awards, including ones from Publishers Weekly and the American Booksellers Association. His newest book, *Other Goose,* is coming out in Fall 2010.

www.jottodotcom.com

Sket One is a painter, illustrator, and designer. He has come a long way since his early days as a New Haven, Conn.,-based graffiti artist in the '80s. In 2003, he started designing toys for all the heavyweight designer toymakers. Sket One has exhibited his custom work both nationally and internationally in various galleries and shows. He displays a passion for uniting distinct components of pop culture into pieces of art that are startlingly cohesive and original. Such innovation has led him to such clients as Universal Music, EMI, DC Comics, Ford, Coca-Cola, Silent Skateboards, and Grind King Trucks.

www.sket-one.com

Shawn Smith is the creative force behind Shawnimals. He started the company before he even knew it by watching cartoons, drawing pictures, and playing video games as a kid. This pop cultural aesthetic comes through in all of the Shawnimals' designs: simple, compelling characters, strong narratives, and a healthy dose of humor. With partner Jen Brody and its staff, Chicago-based Shawnimals has grown quickly from its humble beginnings, now with a Nintendo DS game based on its *Ninjatown* brand, a number of plush and vinyl toys, and much more.

www.shawnimals.com

Winston Smith is mostly known for his numerous album covers for bands such as Dead Kennedys, Green Day, Ben Harper, George Carlin, and Jello Biafra, among others, plus magazine cover art and illustrations for *The New Yorker, Playboy* and *Spin.* A notorious collage artist, he continues to create stunning and surreal hand-cut collage images for custom designs, special commissions, and his international art shows, including *Grant's Tomb,* his San Francisco Gallery, and Studio.

www.winstonsmith.com

California-based artist **Jeff Soto** communicates profound visions, fears, nostalgia of his youth, themes of love, lust, and hope through his work. Inspired by childhood toys, the lifestyle of skateboarding and graffiti, hip-hop and popular culture. Environmental issues also take precedent for Soto, who is concerned with conflict of humans trying to take advantage of nature. His paintings exude this tension, robotic creatures duel, organic tentacles and flower bouquets thrive, and black smog looms amidst floating, ominous skulls. Soto graduated with distinction from Art Center College of Design in Pasadena, Calif., in '02.

www.jeffsoto.com

Damon Soule was spontaneously infused in our solar system via the Magnolia State, 1974, and began expanding annually in a location sometimes referred to as the Crescent City. Around the age of four, he began work on his lifelong pursuit concerning the application of homogenous forms to linear topography. Exposure to such a wide range of serendipity during his formative years provided him with a unique vision, "self-determined entropy can produce highly contagious effects." Damon's visualizations have been exhibited throughout the universe.

www.damonsoule.com

Bwana Spoons was raised in the woods. He likes moss, LEGO and monsters. When he was a little one he would draw detailed crayon renderings of his favorite *Star Wars* figures. When he was older he lost them all in a battle with a mildew giant. He likes making zines and comics and paintings and silk-screen prints and designing toys and making things with rainbows and animals. Recently, Bwana was bitten by the textile bug, designing for Converse, Dekline, MonsieurT., Bumbleride, Nike 6.0., and DC shoes. Bwana has a new book, *Welcome to Forest Island,* and you can visit him anytime at his Portland Headquarters, Grass Hut.

www.grasshutcorp.com

Jophen Stein is a graduate of the Laguna College of Art and Design. He established the *Snootson Family Showcase* series in 2004 and his distinctive style has gained national recognition since his debut. Despite the minor setbacks of being banned from Idaho and Iowa, Jophen Stein continues the *SFSC* series from his studio in Pomona, Calif.

www.scribbletheory.com

Suckadelic is an evil arts organization based in Chinatown, New York. Owned and operated by the mysterious Supervillain, the Super Sucklord, Suckadelic has made a name for itself through creative toy bootlegging and illicit remix records. Since 1997, Suckadelic has successfully blended the opposed worlds of Nerdy fanboys and hipster street cred with a steady stream of ironic action figures, dusted beats, and low-budget sci-fi movies. Best known for his iconic *Gay Empire* bootleg figure, the Super Sucklord has sold swag everywhere from Christie's auction house to the streets of the Lower East Side.

www.suckadelic.com

T9G is a figure artist living in Tokyo. Known for his unique use of doll eyes and other technologies of toy production, he creates 3-D sculptures that embody his unique worldview. He created the shop mascot for Loveless, a high-end shop located in Aoyama, Tokyo. Numerous exhibitions include shows at the Souvenir from Tokyo Space at the National Art Center, Tokyo, the Lobby in Osaka, and Paradise in Taiwan. In 2009, he collaborated with Tim Biskup for the groundbreaking *T&T Show* at Stitch in Daikanyama, Tokyo. He has released figures with Medicom Toy and under his own brand, *T9G / Museum Art Toy*.

www.muse-um.com

Gary Taxali is a Toronto-based award-winning illustrator whose work has appeared in major magazines. He has exhibited in galleries and museums throughout North America and Europe. In 2005, his first vinyl toy debuted, *The Toy Monkey*, which included a special edition commissioned by the Whitney Museum of American Art in New York City. Gary also devotes a portion of his time teaching and lecturing at arts organizations and schools. Gary created the cover art and inside illustrations for Aimee Mann's album *@#%&*! Smilers*, which won a 2009 Grammy Award nomination for Best Package Design.

www.garytaxali.com

Cameron Tiede was raised in Canada on sugar cereal, '80s music, *Peanuts* comics, and classic Nintendo games. Upon completing his first degree in graphic design in the '90s, he headed to Art Center College of Design, where he studied and graduated with distinction in illustration. Tiede has worked as a freelance designer and illustrator for many big clients. Cameron's signature style is infused with raw, energetic characters and stimulating color. His work is exhibited around the world. Collectors and fans anxiously await limited edition custom art toys, paintings, and products, including apparel, snowboards, prints, and vinyl toys.

www.camerontiede.com

Touma worked for 10 years as a character designer at a video game company before moving on as a freelance figure artist in 2001. In 2003, Touma designed his most popular toy, the Knuckle Bear, and achieved great reputation in Japan, Taiwan, Hong Kong, Europe and the U.S. In 2005, Touma established Toumart Inc. and also held his first solo exhibition in the U.S. He has since shown in many other countries around the world to great acclaim. He has released toys and design projects with big clients such as Capcom, Lucasfilm, and Bandai.

www.touma.biz

UrbanMedium is the alias of artist Derek Fridman, whose knack for creating sweet eye candy was born out of a daydream back in 2000 and fueled by the frustration of the 9-to-5 grind. UrbanMedium creates the kind of art you will want to hang on your walls, wear on your body, and plaster all over your environments.

www.urbanmedium.com

Usugrow began his career in 1993 by creating punk rock flyers. He continues to make art for album covers, skateboards, and clothing as well as more personal illustration and paintings. He skillfully and beautifully portrays opposing elements, including delicate lines with a unique lettering style, skulls, and flowers, black and white, yin and yang. With his monochromatic style and the use of only minimum tools, Usugrow's work continues to be shown in galleries around the world.

www.usugrow.com

Brought up in Washington State, **Michelle Valigura** learned from very early on to fear and respect all aspects of the earth. In 1998, eager to create a much-needed new path, she moved to the land of eternal sunlight, Los Angeles. She found her way into stop-motion animation. The progression to fine art sculpture and eventually ceramics was perhaps the most fluid and self-realizing moment throughout her career. Her work has shown in museums and galleries in all corners of the globe, including Disneyland, U.S.A. She is "the other one" of design collective Switcheroo.

www.thegirlsproductions.com

As a kid, **VanBeater** dreamed of being a deadly ninja assassin rapper. Sadly, he discovered his shoes were too squeaky to be a ninja and he ain't never goin' to have good enough grammar to be a bangin' lyricist (You know what I'm sayin'?). Once he came to terms with the facts, he decided to travel from the past to rock the future. Mix that experience with a self-induced pareidolia, a childhood full of influences such as Saturday morning cartoons, NES, and all the toys he couldn't afford to blow up with M-80s but did anyways, and the general love for the never-ending, out of control, run-on sentence, and you have VanBeater.

www.vanbeater.com

Amanda Visell's fine art career sprouted from continuing failure. A high school dropout and CalArts reject, she moved to Los Angeles to pursue a career in traditional animation, eventually finding her way to stop-motion animation as a designer and sculptor, working on stylized projects for shows like *The Simpsons* and the feature film *Elf*. The challenge of mastering new tools and techniques in this medium taught her to be able to visualize her own style. She has been exhibiting her paintings and sculptures internationally since 2005, including Disneyland, U.S.A., and has created a thriving world of characters as designer toys.

www.thegirlsproductions.com

Index

Purchase removal, shipping and offsite storage information

SUCCESSFUL BIDDERS FOR THE PROPERTY FROM THE VADER PROJECT AUCTION WILL BE EXPECTED TO PICK UP ALL PROPERTY FROM FREEMAN'S NO LATER THAN 3 PM ON FRIDAY, JULY 23RD 2010.

Shippers who have worked with Freeman's clients in the past, include but are not limited to:

VG Packaging LLC:
 Contact: Gordon G Murray II
 12 Salem Road
 Schwenksville, PA 19473
 tel: 484-552-8741
 fax: 484-552-8744
 email: quotes@vgpackagingllc.com

UPS Store
 Contact: John Bohach
 51 North 3rd Street
 Philadelphia, PA 19106
 tel: 215.629.4990
 fax: 215.629.4992
 email: store4242@theupsstore.com

Mr. C's
 Contact: Charles Cohen
 tel: 267.977.9567
 email: mrcees61@gmail.com

Cadogan Tate Fine Art
 Cadogan House, 41-20 39th Street
 Sunnyside, New York 11104
 tel: 718.706.7999
 fax: 718.707.2847
 email: michael@cadogantate.com

To ensure the safety of your lot(s) Freeman's requests payment in full and removal of property within ten business days of the sale date. Collection hours are Mon–Fri, 9:30–4:30pm. For larger items, please email bmobbs@freemansauction.com to schedule a loading dock appointment. For purchase release to persons not listed on your invoice, 3rd party authorization is required. Please mail or fax, 215.599.2240, a signed letter stating sale, lot, successful bidder and name of 3rd party collecting property.

Freeman's does not handle packing or shipping. The shippers listed here have worked with Freeman's clients in the past and will be happy to provide you with quotes for the packing and shipping of your property.

Terms & Conditions

ALL PROPERTY OFFERED AND SOLD ("PROPERTY") THROUGH SAMUEL T. FREEMAN & CO, ("FREEMAN'S") SHALL BE OFFERED AND SOLD ON THE TERMS AND CONDITIONS SET FORTH BELOW WHICH CONSTITUTES THE COMPLETE STATEMENT OF THE TERMS AND CONDITIONS ON WHICH ALL PROPERTY IS OFFERED FOR SALE. BY BIDDING AT THE AUCTION, WHETHER PRESENT IN PERSON OR BY AGENT, BY WRITTEN BID, TELEPHONE, INTERNET OR OTHER MEANS, THE BUYER AGREES TO BE BOUND BY THESE TERMS AND CONDITIONS.

1
Unless otherwise indicated, all Property will be offered by Freeman's as agent for the Consignor.

2
Freeman's reserves the right to vary the terms of sale and any such variance shall become part of these Conditions of Sale.

3
Buyer acknowledges that it had the right to make a full inspection of all Property prior to sale to determine the condition, size, repair or restoration of any Property. Therefore, all property is sold "AS-IS". Freeman's is acting solely as an auction broker, and unless otherwise stated, does not own the Property offered for sale and has made no independent investigation of the Property. Freeman's makes no warranty of title, merchantability or fitness for a particular purpose, or any other warranty or representation regarding the description, genuineness, attribution, provenance or condition to the Property of any kind or nature with respect to the Property.

4
Freeman's in its sole and exclusive discretion, reserves the right to withdraw any property, at any time, before the fall of the hammer.

5
Unless otherwise announced by the auctioneer at the time of sale, all bids are per lot as numbered in the printed catalogue. Freeman's reserves the right to determine any and all matters regarding the order, precedence or appropriate increment of bids or the constitution of lots.

6
The highest bidder acknowledged by the auctioneer shall be the buyer. The auctioneer has the right to reject any bid, to advance the bidding at his absolute discretion and in the event of any dispute between bidders, the auctioneer shall have the sole and final discretion either to determine the successful bidder or to re-offer and resell the article in dispute. If any dispute arises after sale, the Freeman's sale record shall be conclusive in all respects.

7
If the auctioneer determines that any opening or later bid or any advance bid is not commensurate with the value of the Property offered, he may reject the same and withdraw the Property from sale.

8
Upon the fall of the hammer, title to any offered lot or article will immediately pass to the highest bidder as determined in the exclusive discretion of the auctioneer, subject to compliance by the buyer with these Conditions of Sale. Buyer thereupon assumes full risk and responsibility of the property sold, agrees to sign any requested confirmation of purchase, and agrees to pay the full price, plus Buyer's Premium, therefore or such part, upon such terms as Freeman's may require.

9
No lot may be removed from Freeman's premises until the buyer has paid in full the purchase price therefor including Buyer's Premium or has satisfied such terms that Freeman's, in its sole discretion, shall require. Subject to the foregoing, all Property shall be paid for and removed by the buyer at his/her expense within ten (10) days of sale and, if not so removed, may be sold by Freeman's, or sent by Freeman's to a public warehouse, at the sole risk and charge of the buyer(s), and Freeman's may prohibit the buyer from participating, directly or indirectly, as a bidder or buyer in any future sale or sales. In addition to other remedies available to Freeman's by law, Freeman's reserves the right to impose a late charge of 1.5% per month of the total purchase price on any balance remaining ten (10) days after the day of sale. If Property is not removed by the buyer within ten (10) days, a handling charge of .1% of the total purchase price per month from the tenth day after the sale until removal by the buyer shall be payable to Freeman's by the buyer; Freeman's shall charge 1.5% of the total purchase price per month for any property not so removed within 60 days after the sale. Freeman's will not be responsible for any loss, damage, theft, or otherwise responsible for any goods left in Freeman's possession after ten (10) days. If the foregoing conditions or any applicable provisions of law are not complied with, in addition to other remedies available to Freeman's and the Consignor (including without limitation the right to hold the buyer(s) liable for the bid price) Freeman's, at its option, may either cancel the sale, retaining as liquidated damages all payments made by the buyer(s), or resell the property. In such event, the buyer(s) shall remain liable for any deficiency in the original purchase price and will also be responsible for all costs, including warehousing, the expense of the ultimate sale, and Freeman's commission at its regular rates together with all related and incidental charges, including legal fees. Payment is a precondition to removal. Payment shall be by cash, certified check or similar bank draft, or any other method approved by Freeman's. Checks will not be deemed to constitute payment until cleared. Any exceptions must be made upon Freeman's written approval of credit prior to sale.
In addition, a defaulting buyer will be deemed to have granted and assigned to Freeman's, a continuing security interest of first priority in any property or money of, or owing to such buyer in Freeman's possession, and Freeman's may retain and apply such property or money as collateral security for the obligations due to due to Freeman's. Freeman's shall have all of the rights accorded a secured party under the Pennsylvania Uniform Commercial Code.

10
Unless the sale is advertised and announced as "without reserve", each lot is offered subject to a reserve and Freeman's may implement such reserves by bidding through its representatives on behalf of the Consignors. In certain instances, the Consignor may pay less than the standard commission rate where Freeman's or its representative is a successful bidder on behalf of the Consignor. Where the Consignor is indebted to Freeman's, Freeman's may have an interest in the offered lots and the proceeds therefrom, other than the broker's Commissions, and all sales are subject to any such interest.

11
No "buy" bids shall be accepted at any time for any purpose.

12
Any pre-sale bids must be submitted in writing to Freeman's prior to commencement of the offer of the first lot of any sale. Freeman's copy of any such bid shall conclusively be deemed to be the sole evidence of same, and while Freeman's accepts these bids for the convenience of bidders not present at the auction, Freeman's shall not be responsible for the failure to execute, or, to execute properly, any pre-sale bid.

13
A Buyer's Premium will be added to the successful bid price and is payable by the buyer as part of the total purchase price. The Buyer's Premium shall be: 25% on the first $20,000 of the hammer price of each lot, 20% on the portion from $20,001 through $500,000, and 12% on the portion of the hammer price exceeding $500,000.

14
Unless exempted by law from the payment thereof, the buyer will be required to pay any and all federal excise tax and any state and/or local sales taxes, including where deliveries are to be made outside the state where a sale is conducted, which may be subject to a corresponding or compensating tax in another state.

15
Freeman's may, as a service to buyer arrange to have purchased property posted and shipped at the buyer's expense. Freeman's is not responsible for any acts or omissions in packing or shipping of purchased lots whether or not such carrier recommended by Freeman's. Packing and handling of purchased lots is at the responsibility of the buyer and is at the entire risk of the buyer.

16
In no event shall any liability of Freeman's to the buyer exceed the purchase price actually paid.

17
No claimed modification or amendment of this Agreement on the part of any party shall be deemed extant, enforceable or provable unless it is in writing that has been signed by the parties to this Agreement. No course of dealing and no delay or omission on the part of Freeman's in exercising any right under this Agreement shall operate as a waiver of such right or any other right and waiver on any one or more occasions shall not be construed as a bar to or waiver of any right or remedy of Freeman's on any future occasion.

18
These Conditions of Sale and the buyer's, the Consignor's and Freeman's rights under these Conditions of Sale shall be governed by, construed and enforced in accordance with the laws of the Commonwealth of Pennsylvania and Consignor and Buyer agree to the exclusive jurisdiction of the Philadelphia, Pennsylvania Court of Common Pleas and the United States District Court for the Eastern District of Pennsylvania.

Pop Culture 09/03/10

FREEMAN'S
AUCTIONEERS & APPRAISERS SINCE 1805

Auction: Friday, September 3rd at Noon

Exhibitions:
Tuesday, August 31st through
Thursday, September 2nd
10am - 6pm

Inquiries:
SIMEON LIPMAN 267.414.1213
slipman@freemansauction.com

KATI GEGENHEIMER 267.414.1212
kgegenheimer@freemansauction.com

Detail of:
CHARLES PETERSON
KURT COBAIN
Original black and white
photograph, signed
11 x 14 in.
$800-1,200
(£500-750)

www.freemansauction.com

Directory

SPECIALIST DEPARTMENTS

American Furniture, Decorative & Folk Art
LYNDA A CAIN
SAMUEL M FREEMAN II
AMY PARENTI

Asian Arts
ROBERT WATERHOUSE
RICHARD CERVANTES

English & Continental Furniture, Silver & Decorative Arts
ROBERT WATERHOUSE
DOUGLAS GIRTON
KERRY JEFFERY

Fine Jewelry
SAMUEL M FREEMAN II
KATE WATERHOUSE

Fine Paintings & Sculpture
ALASDAIR NICHOL
DAVID WEISS
LIBIA ELENA MENDEZ
MAYA O'DONNELL-SHAH
AIMEE PFLIEGER DOLBY

Fine Prints
ANNE HENRY
DAVID WEISS
AIMEE PFLIEGER DOLBY
LIBIA ELENA MENDEZ

Modern & Contemporary Art
ANNE HENRY
ALASDAIR NICHOL
DAVID WEISS
AIMEE PFLIEGER DOLBY

Pop Culture
SIMEON LIPMAN
KATI GEGENHEIMER

Oriental Rugs & Tapestries
DAVID WEISS
RICHARD CERVANTES

Rare Books, Manuscripts, & Ephemera
DAVID J BLOOM
JOE HUENKE

DEPARTMENTS

Appraisals
ANITA HERIOT
SAMUEL M FREEMAN II
JAMES E BUCKLEY
DONALD E WALTER

Appraisal Services
ANDREA VAINIUS
ELTON-JOHN TORRES
KATE MOLETS

Museum Services
THOMAS B. MCCABE IV
LYNDA A CAIN

Client Services
MARY MAGUIRE CARROLL
KATI GEGENHEIMER
NATALIE DIFELICIANTONIO
JESSICA CARTER
BETHANY MOBBS
SUSANNAH HENDERSON
MEGHAN STYLES JONES

Operations
HANNA DOUGHER
MARCELL ZOMBORI
BETHANY MOBBS
NATHAN NORLEY
DAVID EDEDANE
GERALD DAVIS
THEO REINKE
ALEX HAMPSHIRE

Finance
HANNA DOUGHER
JEFFREY MILLER

Business Development & Marketing
TARA THEUNE DAVIS
THOMAS B. MCCABE IV
LILY STONE
CHRISTOPHER BROWNE

Trusts & Estates
SAMUEL T FREEMAN III
THOMAS B. MCCABE IV

Photography
ELIZABETH FIELD
ELIZABETH SCHULTZ
THOM CLARK

OFFICERS

CHAIRMAN
SAMUEL M FREEMAN II

VICE CHAIRMAN
MARGARET FREEMAN

VICE CHAIRMAN
ALASDAIR NICHOL

PRESIDENT
PAUL ROBERTS

EXECUTIVE VICE PRESIDENTS
JAMES E BUCKLEY
HANNA DOUGHER

CHIEF FINANCIAL OFFICER
ERIC A SMITH

VICE PRESIDENTS
DAVID J BLOOM
LYNDA A CAIN
ANNE HENRY
ROBERT WATERHOUSE
DAVID WEISS

REPRESENTATIVES
DAVID WEISS
Washington, DC
dweiss@freemansauction.com
Telephone: 202.412.8345

COLIN CLARKE
Charlottesville, VA
cclarke@freemanssouth.com
Telephone: 434.296.4096
Fax: 434.296.4011

ROBERT AND KATE WATERHOUSE
Annapolis, MD
rwaterhouse@freemansauction.com
Telephone: 267.414.1226